A piggy scene

You could draw any kind of flowers. These are tulips.

For lettuce leaves, draw wiggly green shapes.

Green spikes for grass

Wavy brown lines for mud

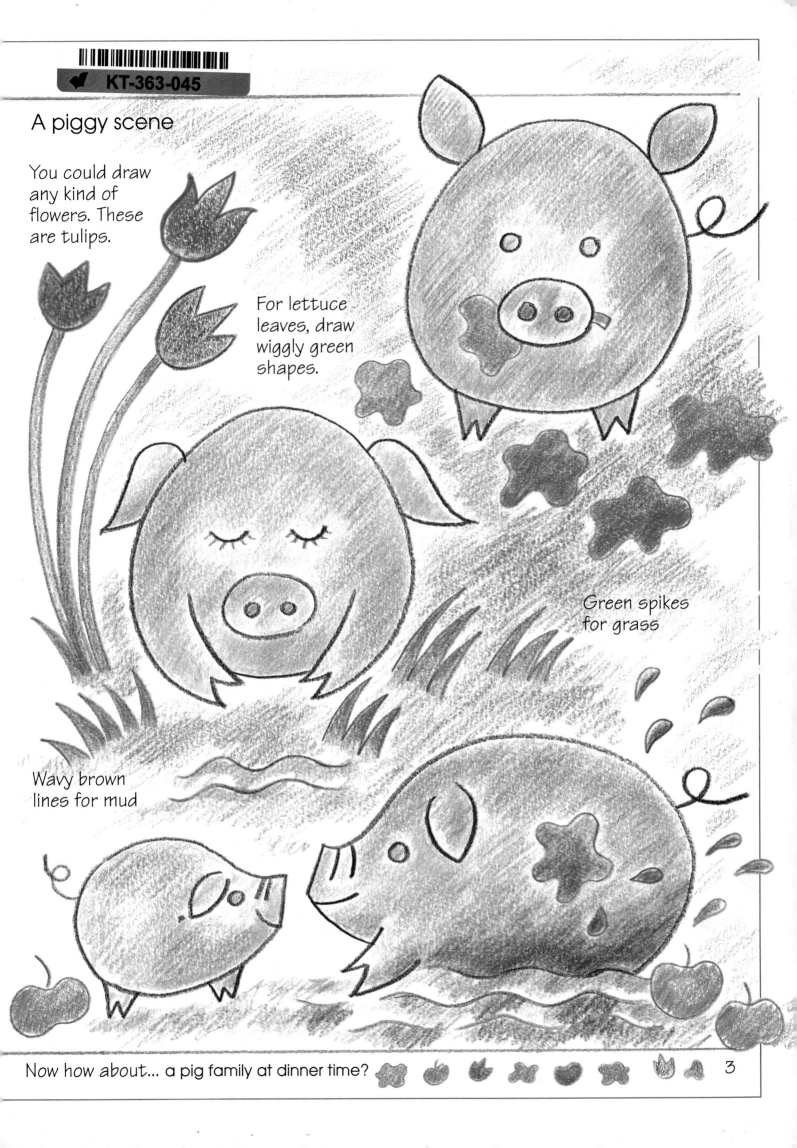

Now how about... a pig family at dinner time?

3

Draw a sea monster

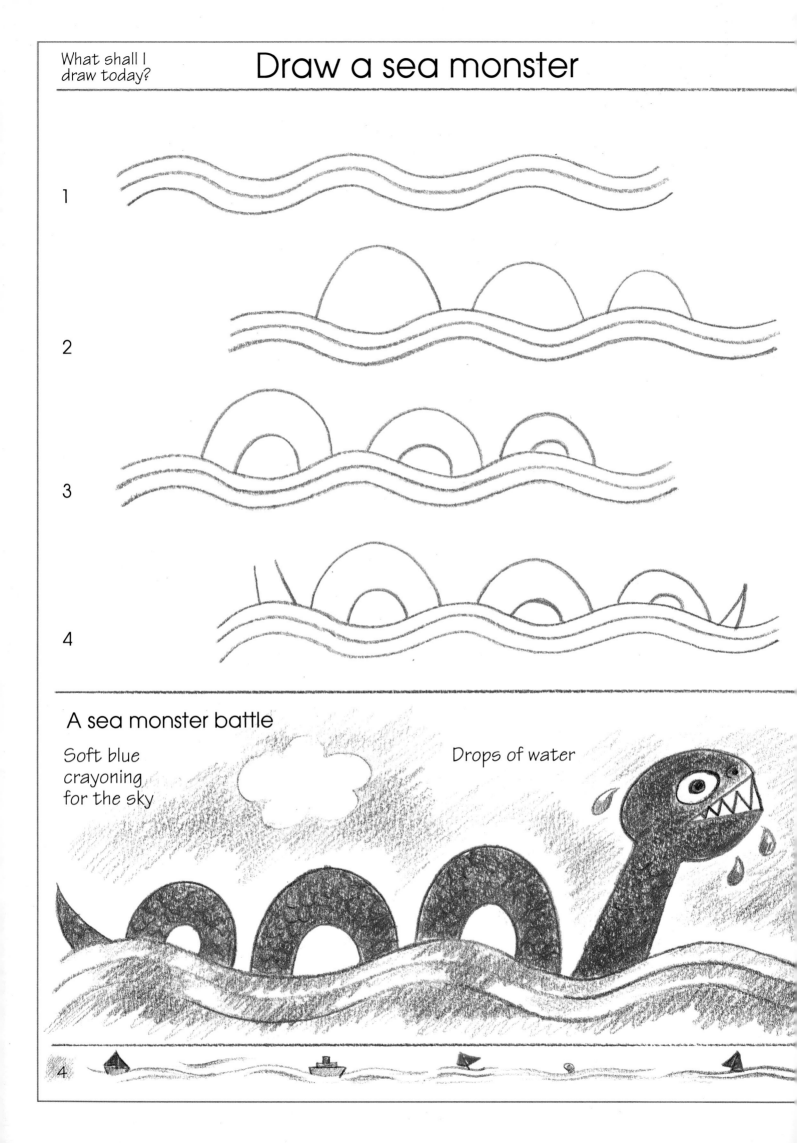

1

2

3

4

A sea monster battle

Soft blue crayoning for the sky

Drops of water

What shall I draw?

Ray Gibson

Designed and illustrated by Amanda Barlow

Edited By Felicity Everett
Series Editor: Jenny Tyler

Contents

Draw a pig

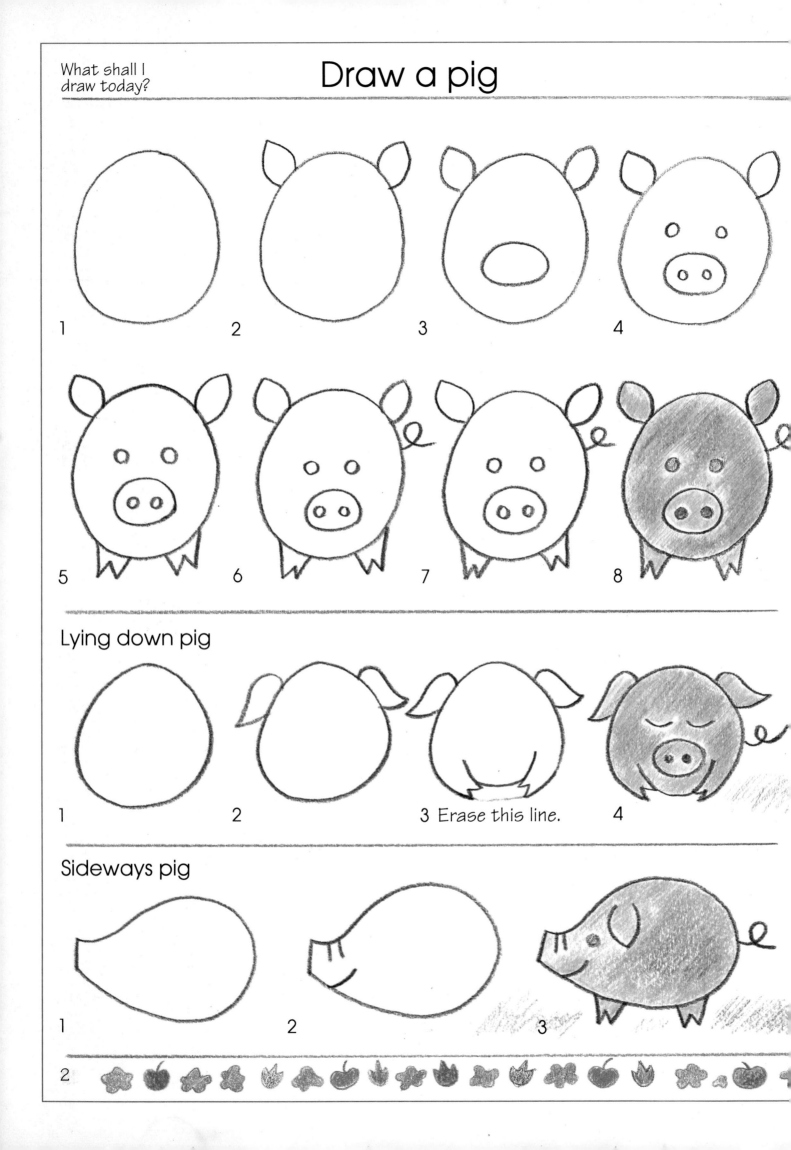

1

2

3

4

5

6

7

8

Lying down pig

1

2

3 Erase this line.

4

Sideways pig

1

2

3

2

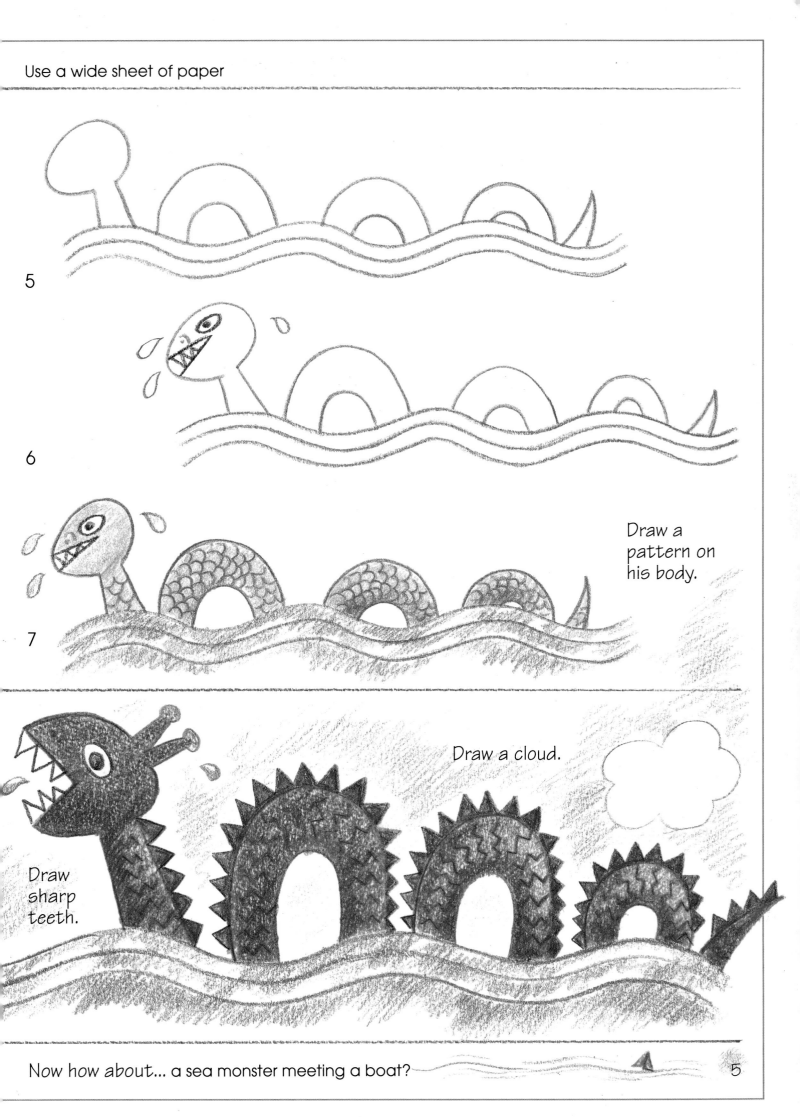

Use a wide sheet of paper

5

6

Draw a pattern on his body.

7

Draw a cloud.

Draw sharp teeth.

Now how about... a sea monster meeting a boat?

Draw a snail

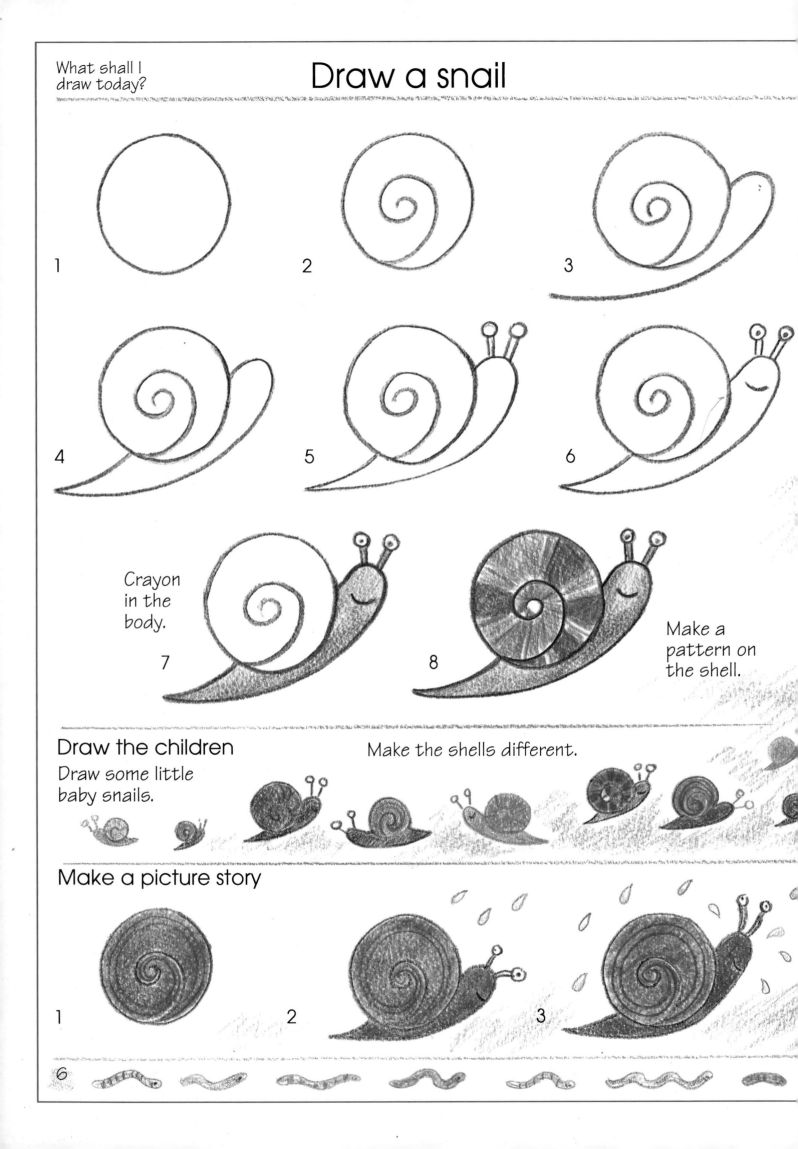

1

2

3

4

5

6

Crayon
in the
body.

7

8

Make a
pattern on
the shell.

Draw the children

Make the shells different.

Draw some little
baby snails.

Make a picture story

1

2

3

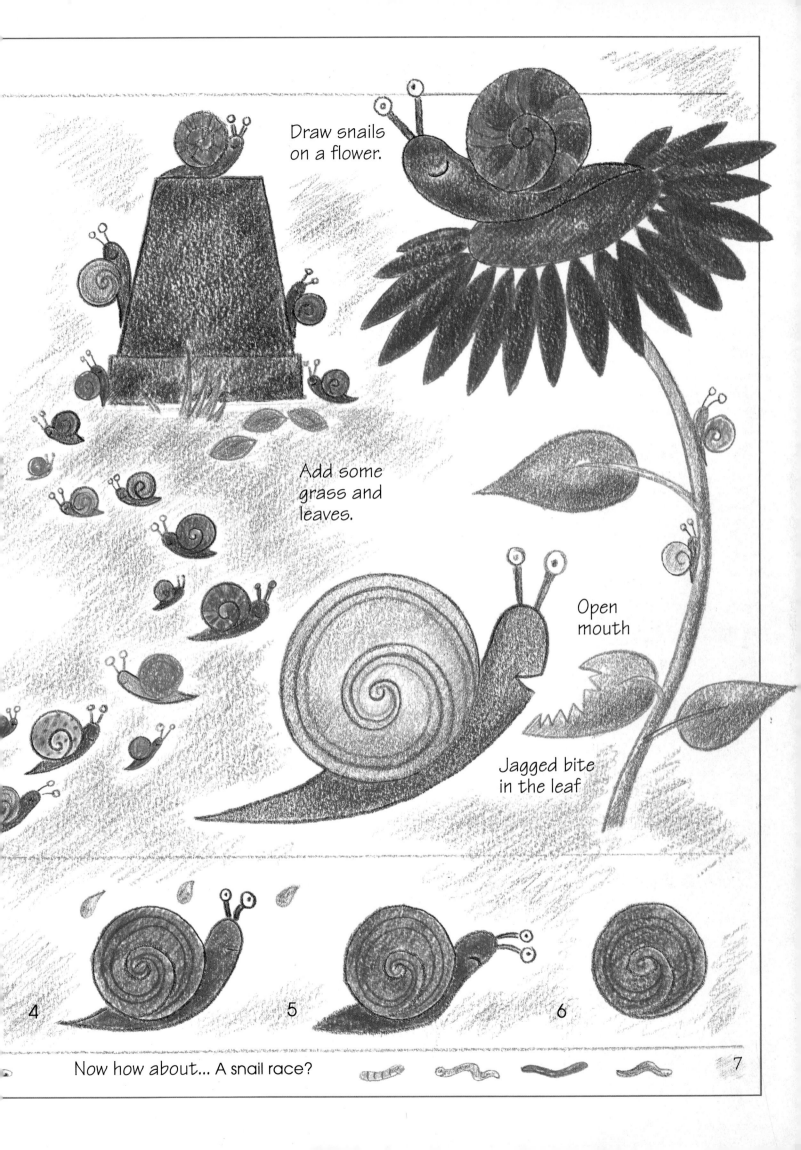

Draw snails on a flower.

Add some grass and leaves.

Open mouth

Jagged bite in the leaf

4

5

6

Now how about... A snail race?

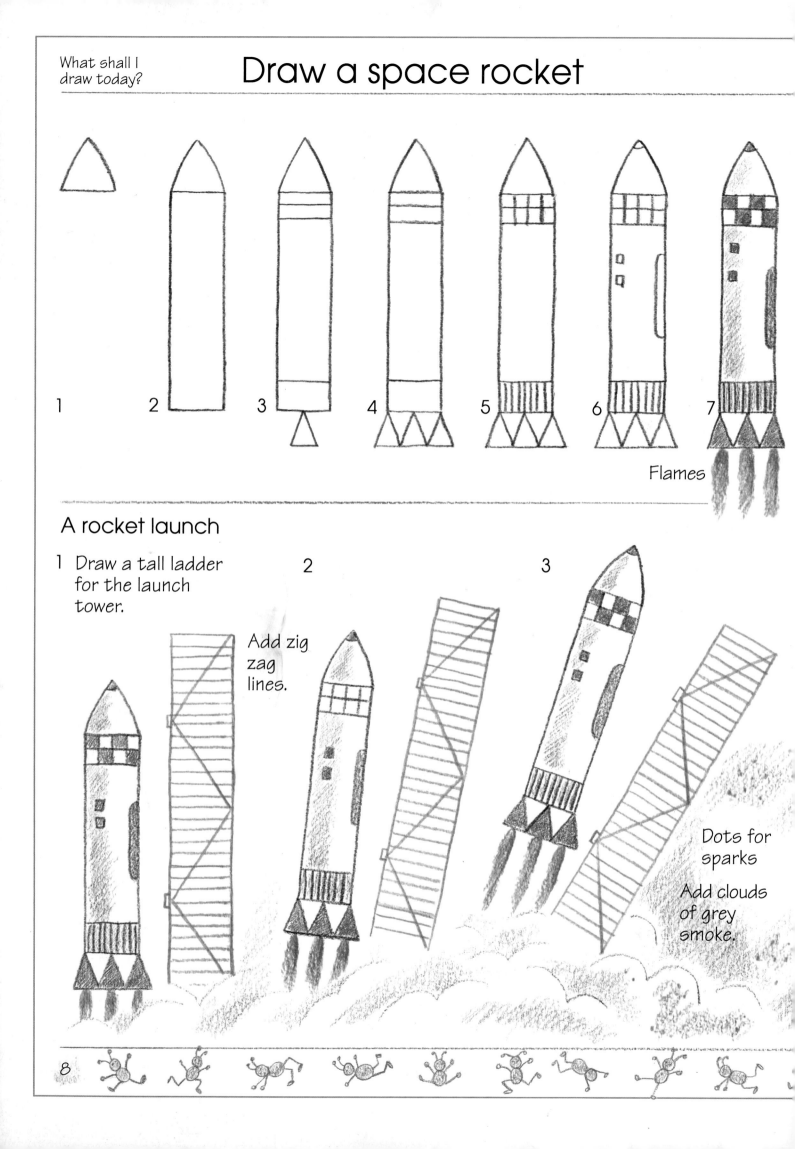

Draw a space rocket

1

2

3

4

5

6

7 Flames

A rocket launch

1 Draw a tall ladder for the launch tower.

2 Add zig zag lines.

3

Dots for sparks

Add clouds of grey smoke.

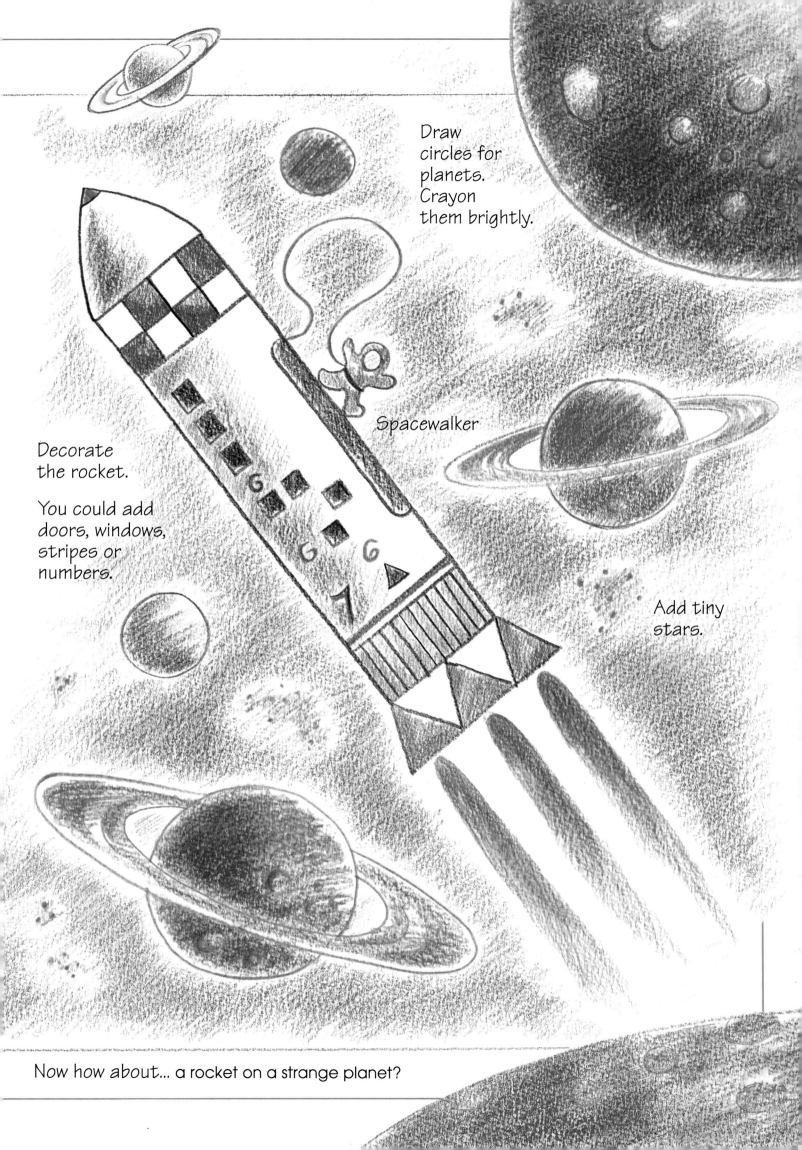

Draw circles for planets. Crayon them brightly.

Spacewalker

Decorate the rocket.

You could add doors, windows, stripes or numbers.

Add tiny stars.

Now how about... a rocket on a strange planet?

Draw an owl

Start with a branch.

1

2

3

Draw a dot here.

4

5

6

7

8

9

10

Draw scribbly stripes on the wings.

11

Shade around the eyes.

12

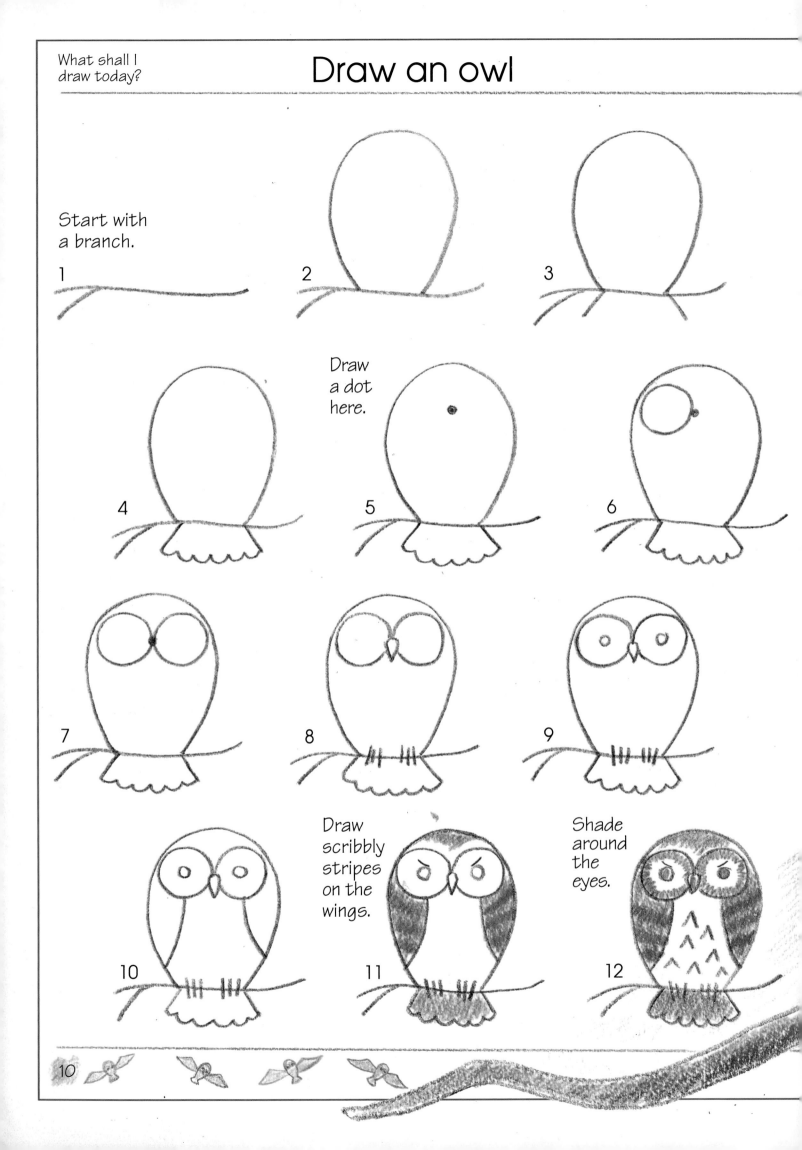

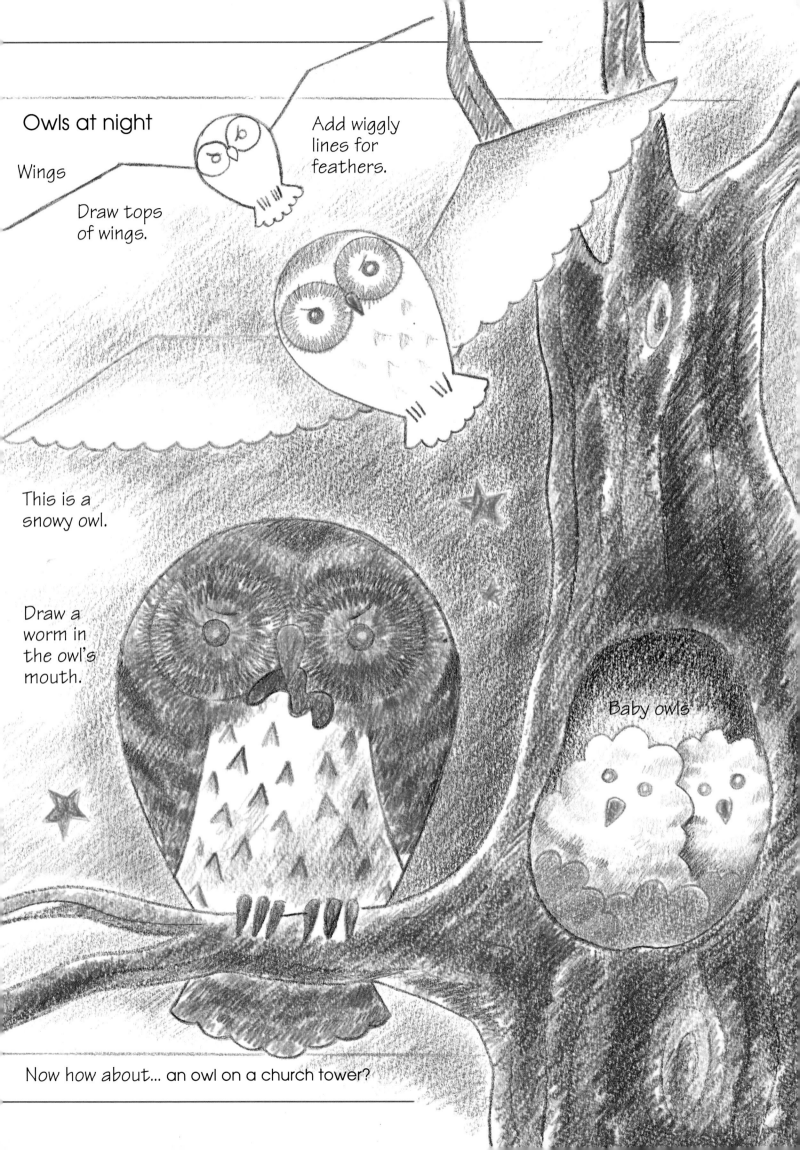

Owls at night

Wings

Draw tops
of wings.

Add wiggly
lines for
feathers.

This is a
snowy owl.

Draw a
worm in
the owl's
mouth.

Baby owls

Now how about... an owl on a church tower?

Draw a submarine

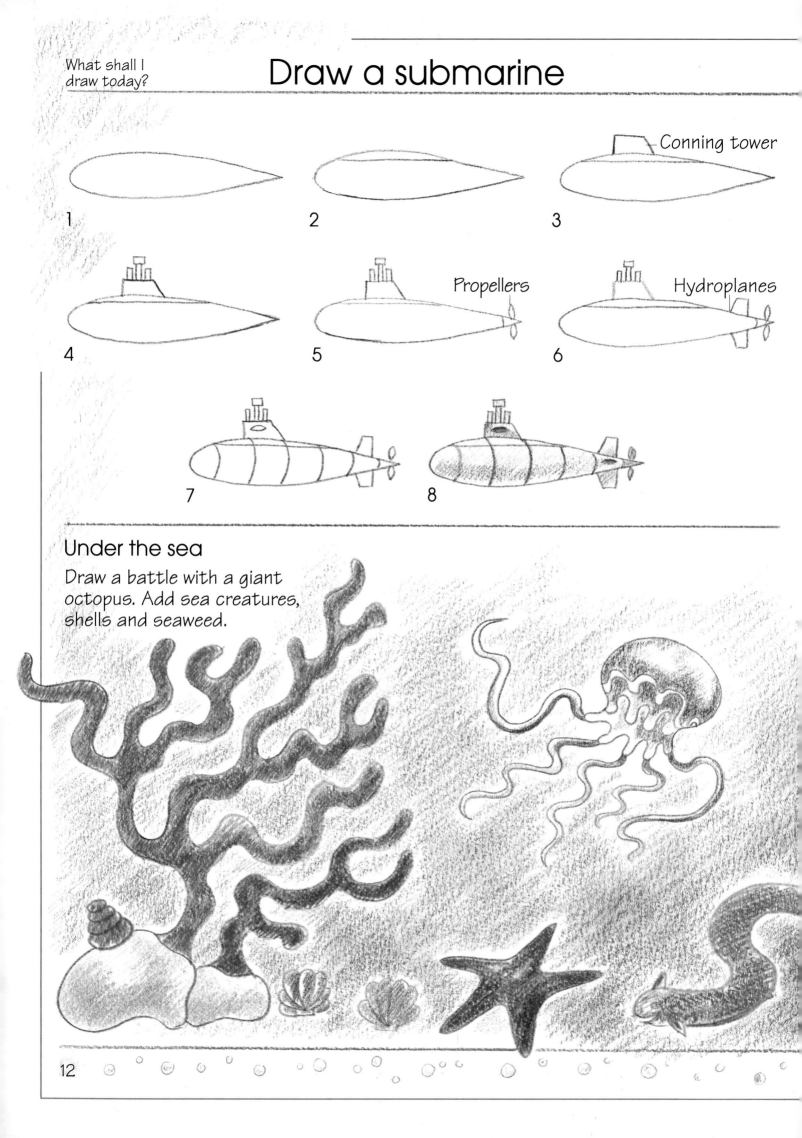

Conning tower

1

2

3

4

5 Propellers

6 Hydroplanes

7

8

Under the sea

Draw a battle with a giant octopus. Add sea creatures, shells and seaweed.

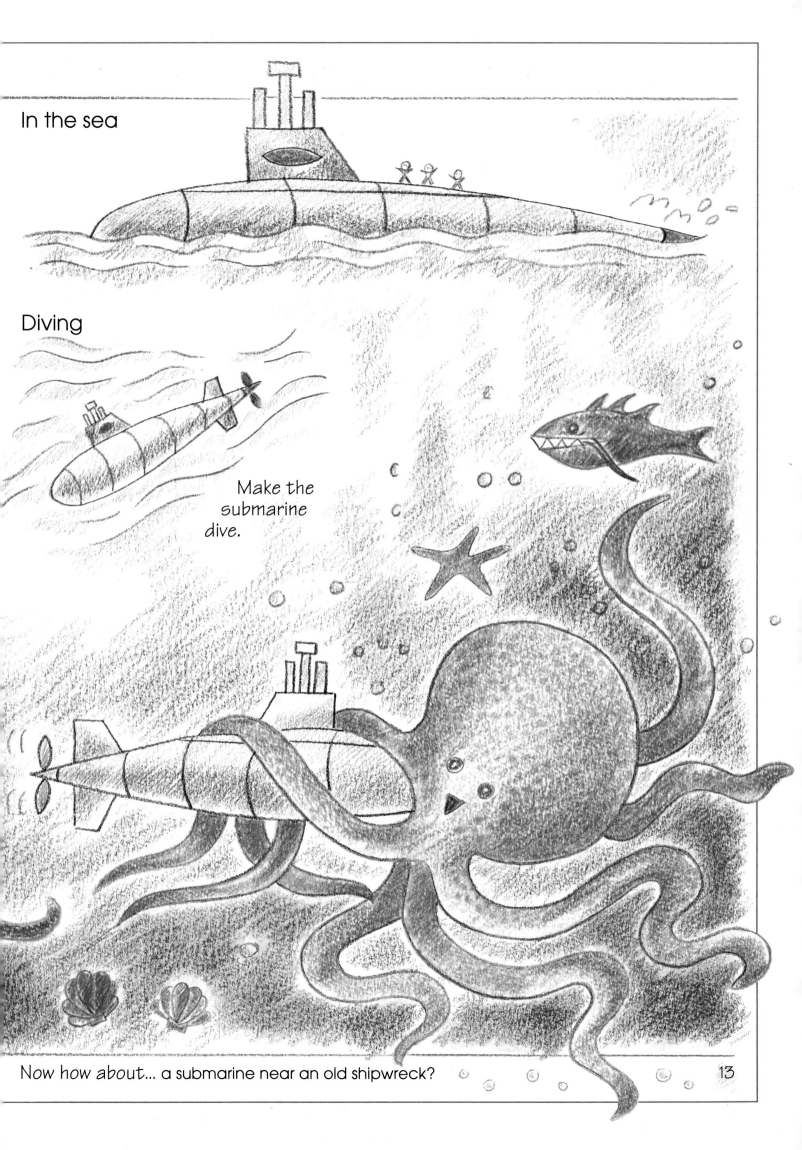

In the sea

Diving

Make the
submarine
dive.

Now how about... a submarine near an old shipwreck?

Draw a tiger

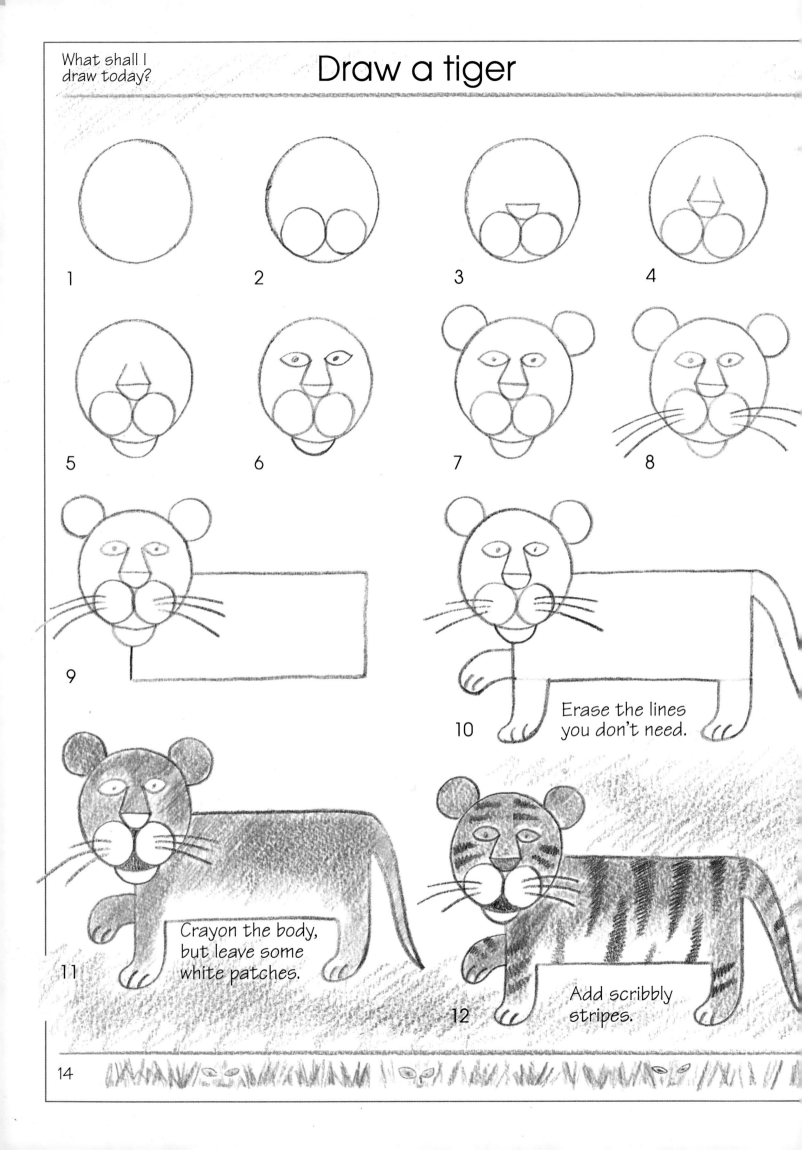

1

2

3

4

5

6

7

8

9

10 Erase the lines you don't need.

11 Crayon the body, but leave some white patches.

12 Add scribbly stripes.

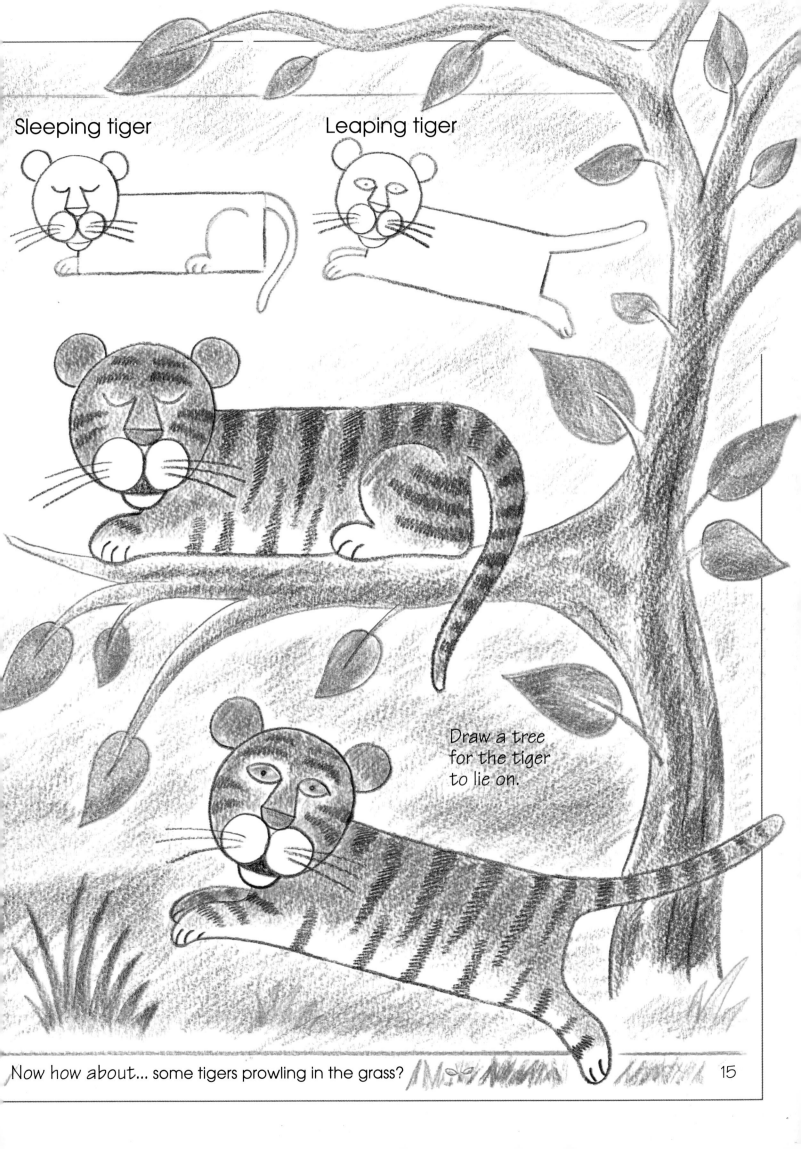

Sleeping tiger

Leaping tiger

Draw a tree
for the tiger
to lie on.

Now how about... some tigers prowling in the grass?

15

Draw a wizard

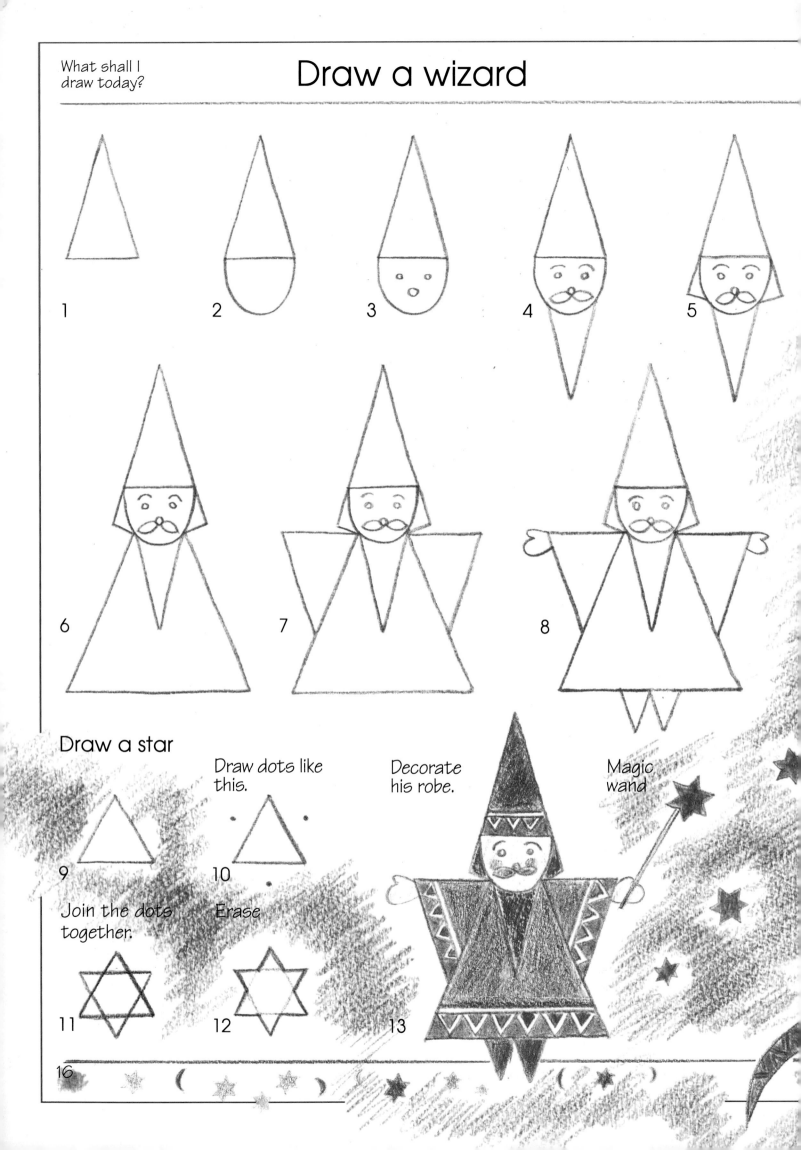

1

2

3

4

5

6

7

8

Draw a star

Draw dots like this.

Decorate his robe.

Magic wand

9

10

Join the dots together.

Erase

11

12

13

16

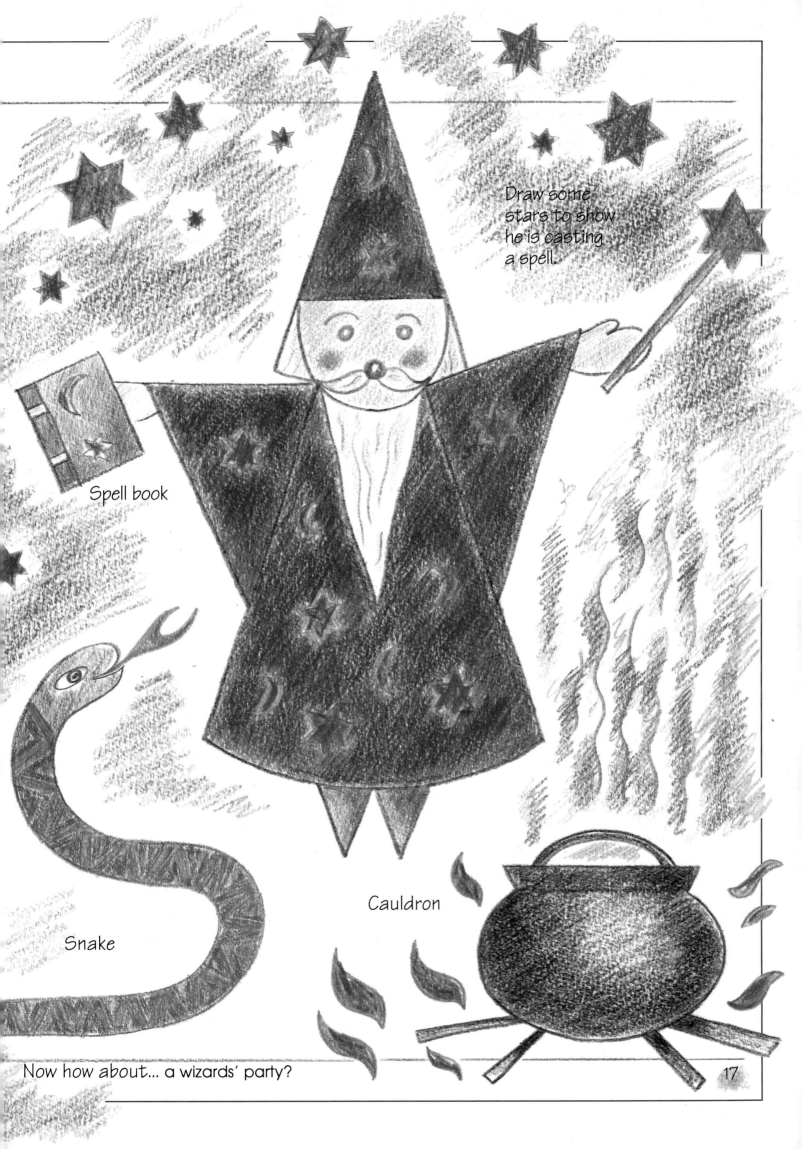

Draw some stars to show he is casting a spell.

Spell book

Snake

Cauldron

Now how about... a wizards' party?

Draw a helicopter

1

2

3

4

5

6

Lines
around
the tail propeller
make it seem to move.

7

8

Crayon
your
helicopter.

More flying 'copters

These
helicopters
are rescuing
people.

This one
has skids
underneath,
so it can land
on the water.

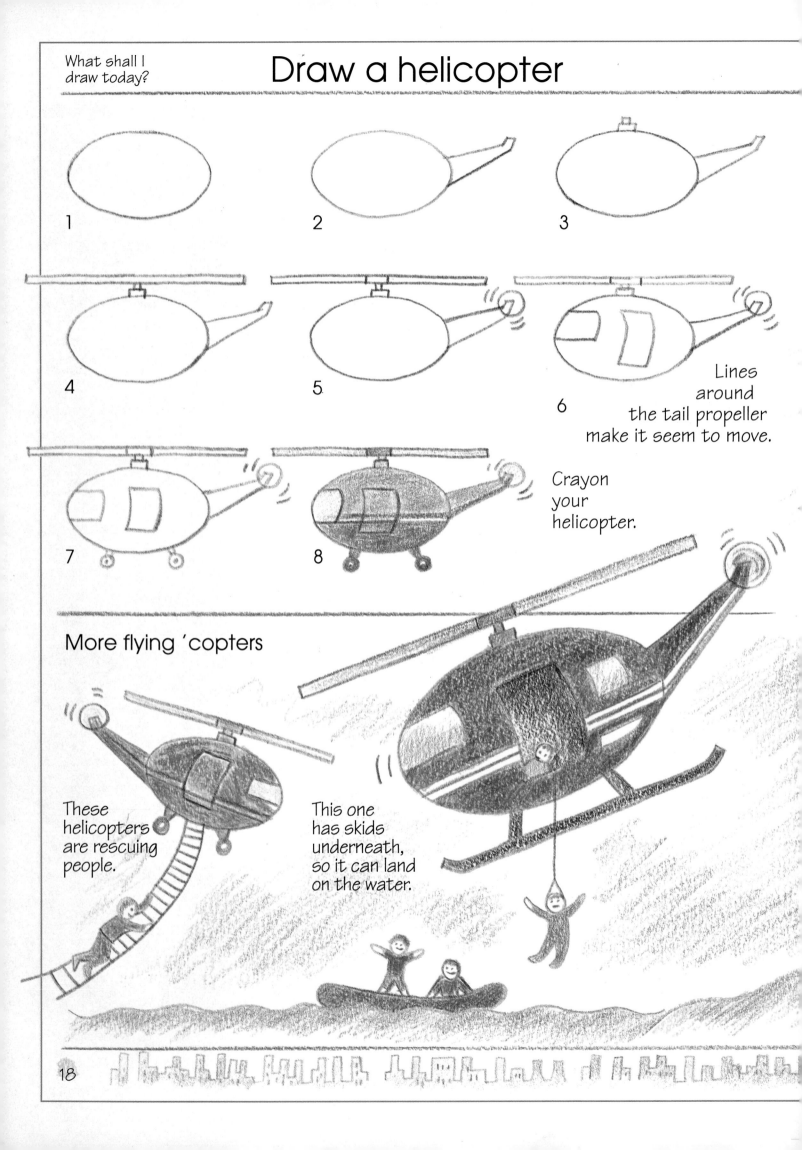

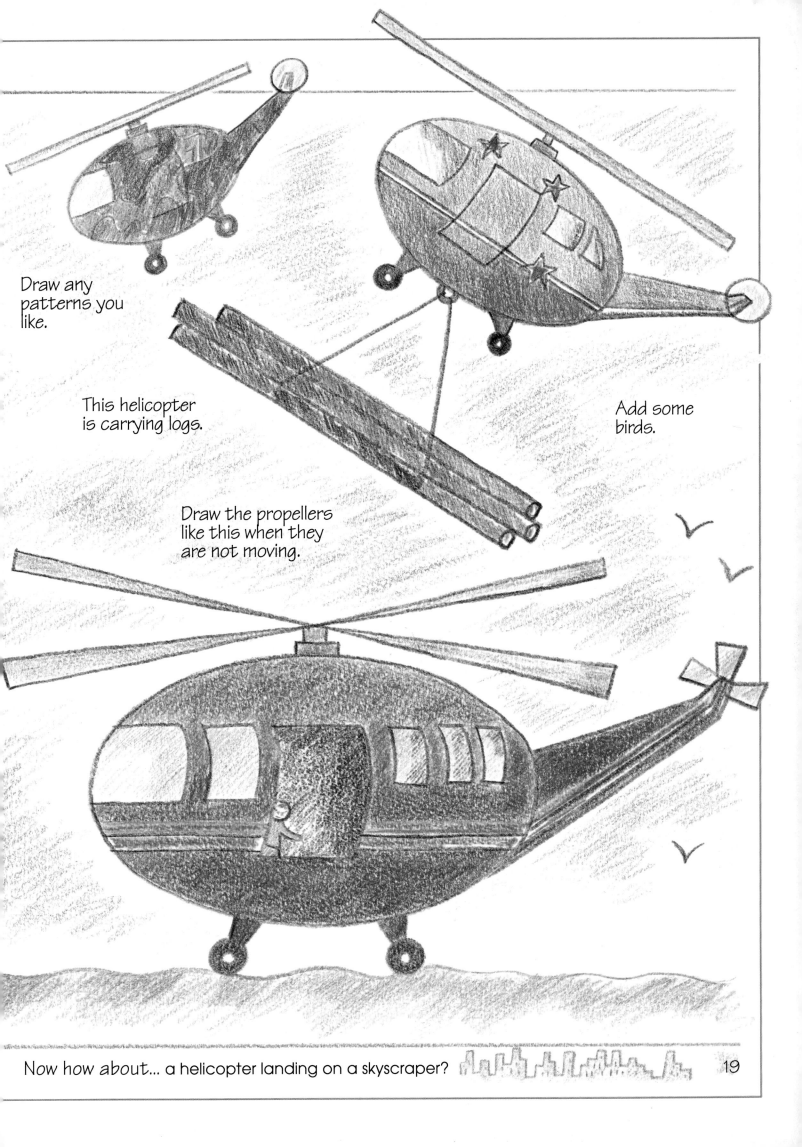

Draw any patterns you like.

This helicopter is carrying logs.

Draw the propellers like this when they are not moving.

Add some birds.

Now how about... a helicopter landing on a skyscraper?

Draw a cat

Snoozing cat

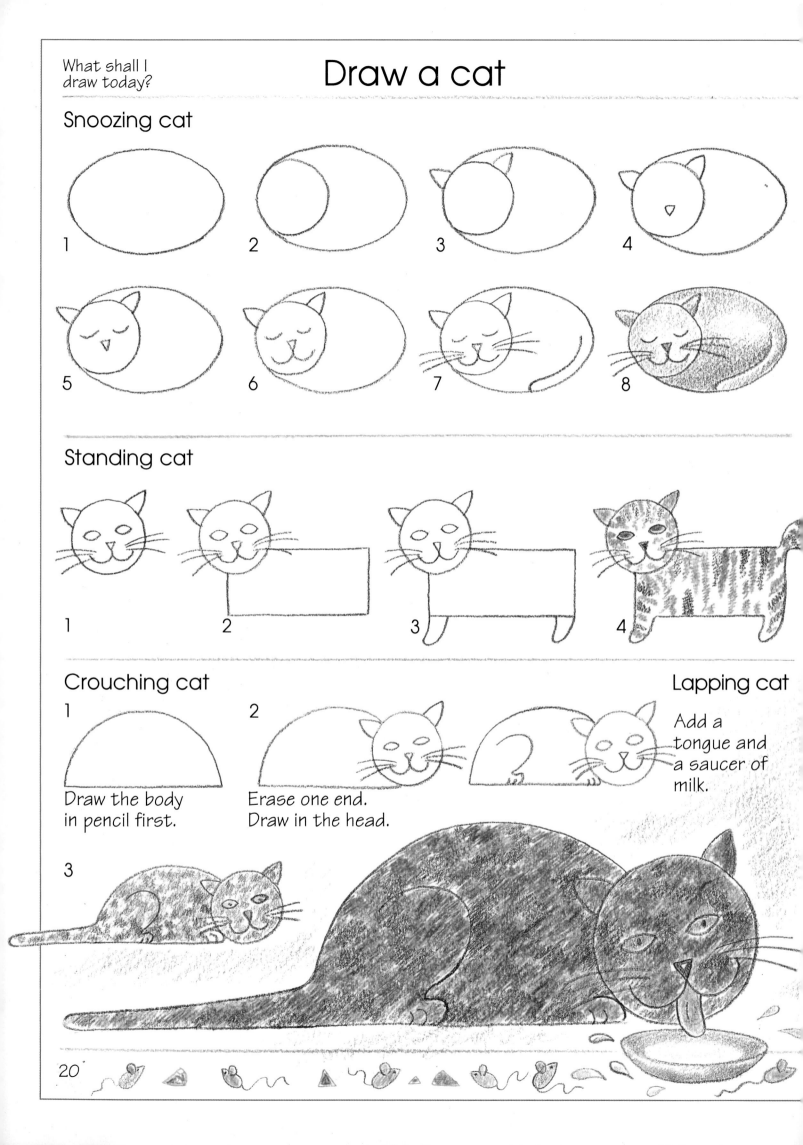

1

2

3

4

5

6

7

8

Standing cat

1

2

3

4

Crouching cat

1

Draw the body
in pencil first.

2

Erase one end.
Draw in the head.

Lapping cat

Add a
tongue and
a saucer of
milk.

3

Sitting cat

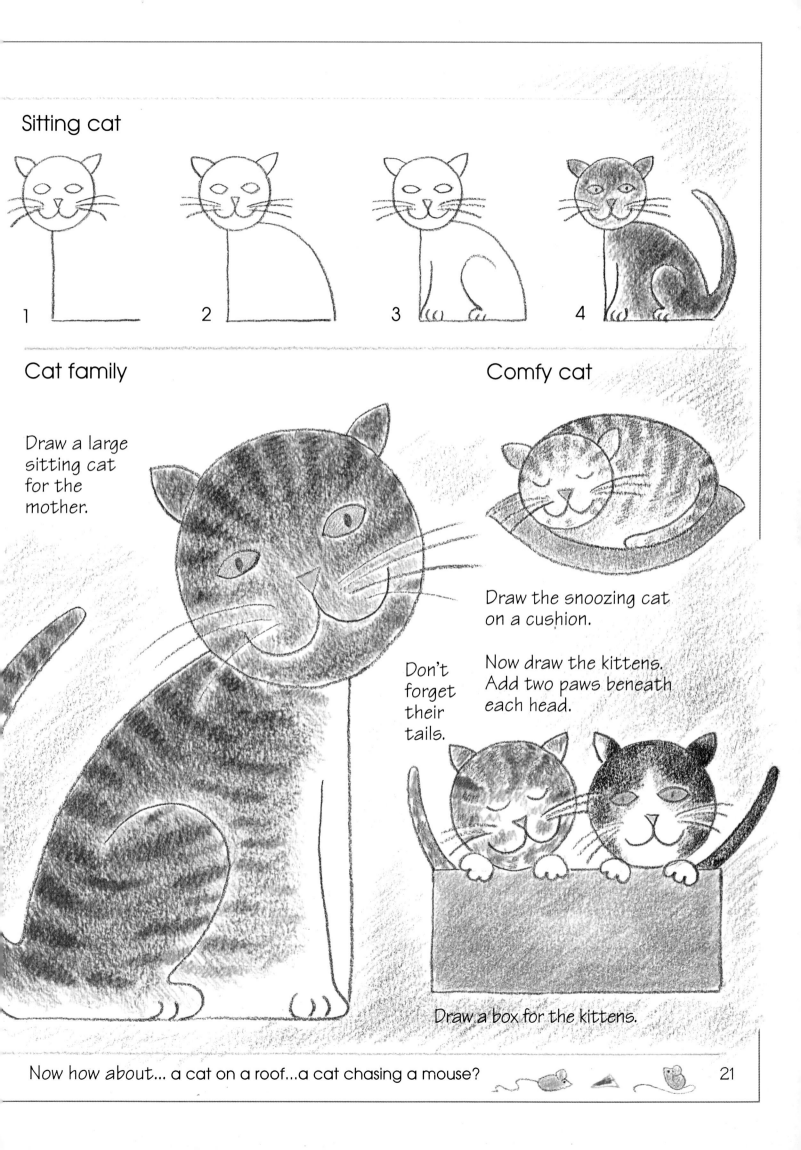

1 2 3 4

Cat family

Draw a large sitting cat for the mother.

Comfy cat

Draw the snoozing cat on a cushion.

Now draw the kittens. Add two paws beneath each head.

Don't forget their tails.

Draw a box for the kittens.

Now how about... a cat on a roof...a cat chasing a mouse?

Draw circles

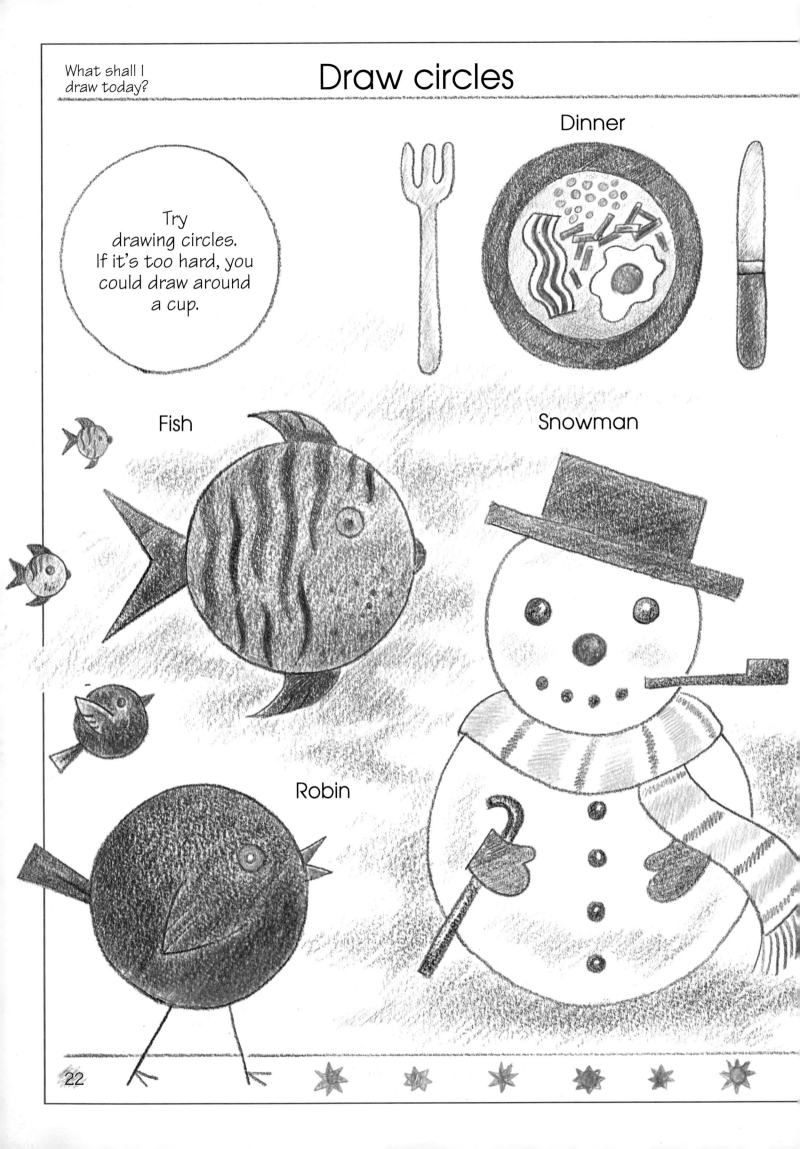

Dinner

Try
drawing circles.
If it's too hard, you
could draw around
a cup.

Fish

Snowman

Robin

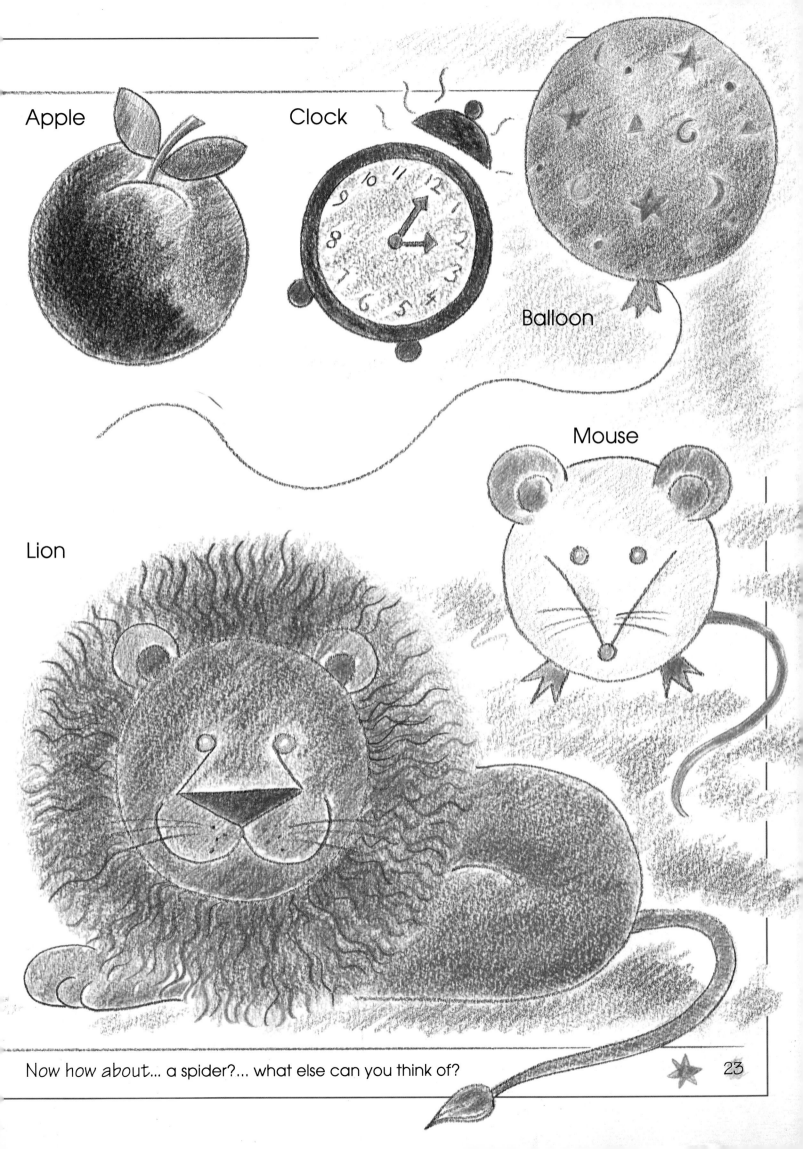

Apple

Clock

Balloon

Mouse

Lion

Now how about... a spider?... what else can you think of?

Draw a clown

What shall I draw today?

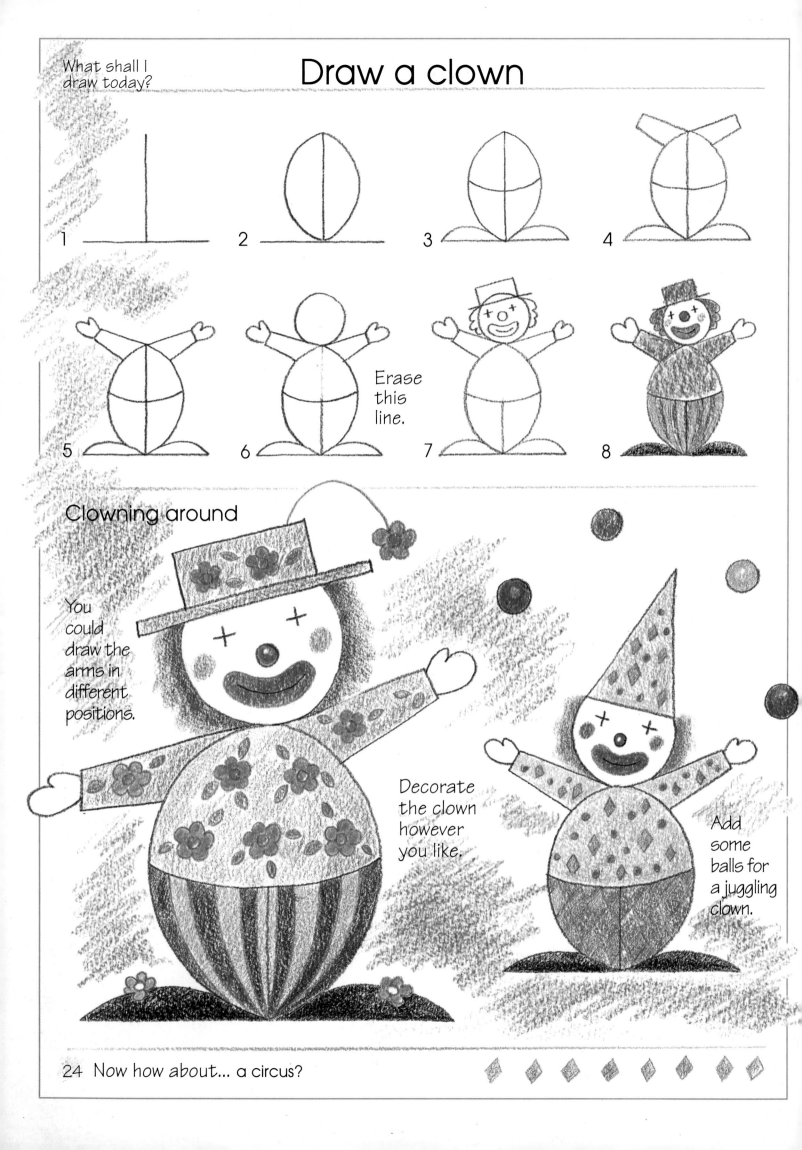

1

2

3

4

5

6 Erase this line.

7

8

Clowning around

You could draw the arms in different positions.

Decorate the clown however you like.

Add some balls for a juggling clown.

Now how about... a circus?

Draw a ballerina

What shall I draw today?

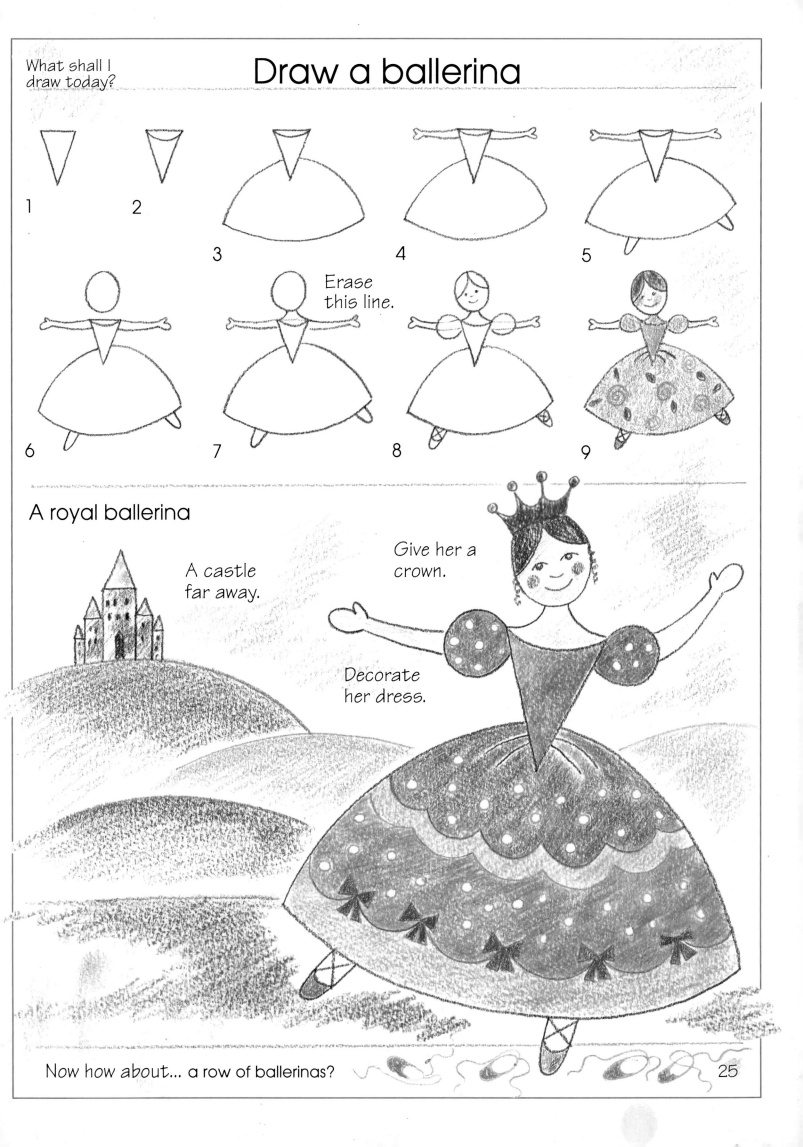

1

2

3

4

5

Erase this line.

6

7

8

9

A royal ballerina

A castle far away.

Give her a crown.

Decorate her dress.

Now how about... a row of ballerinas?

Draw a teddy

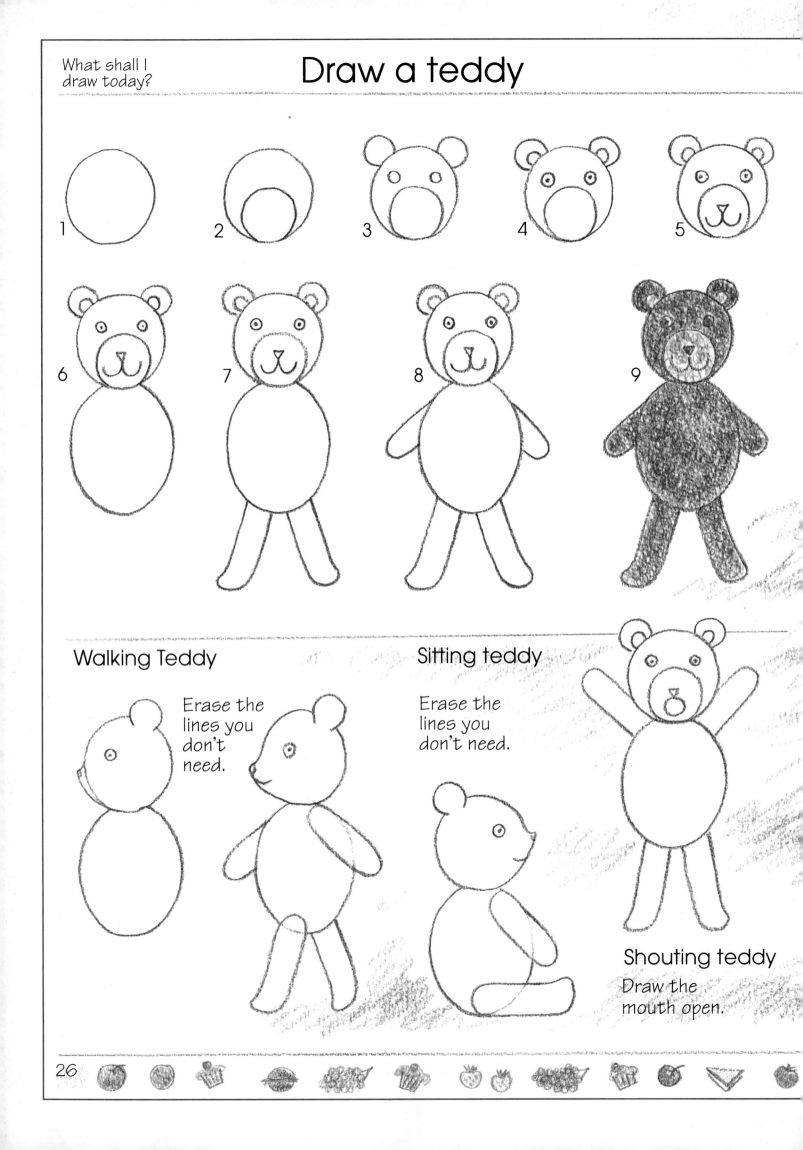

1
2
3
4
5
6
7
8
9

Walking Teddy

Erase the lines you don't need.

Sitting teddy

Erase the lines you don't need.

Shouting teddy

Draw the mouth open.

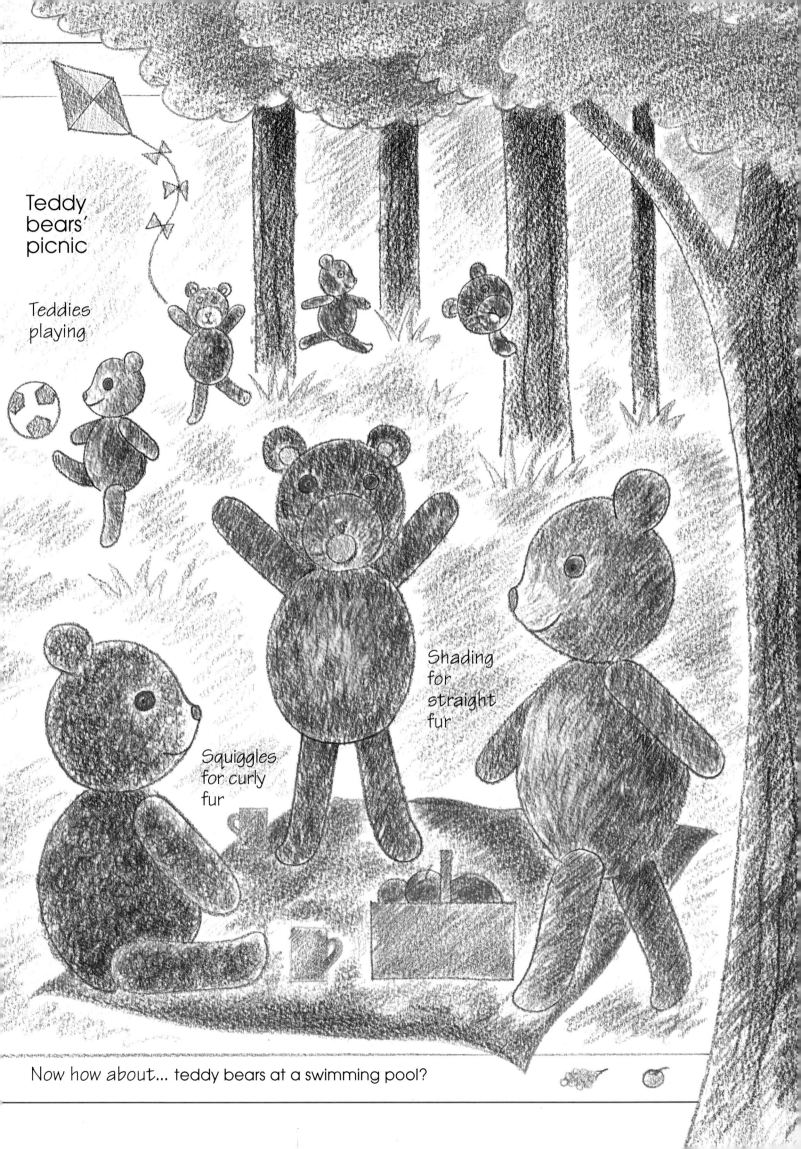

Teddy
bears'
picnic

Teddies
playing

Shading
for
straight
fur

Squiggles
for curly
fur

Now how about... teddy bears at a swimming pool?

Draw a castle

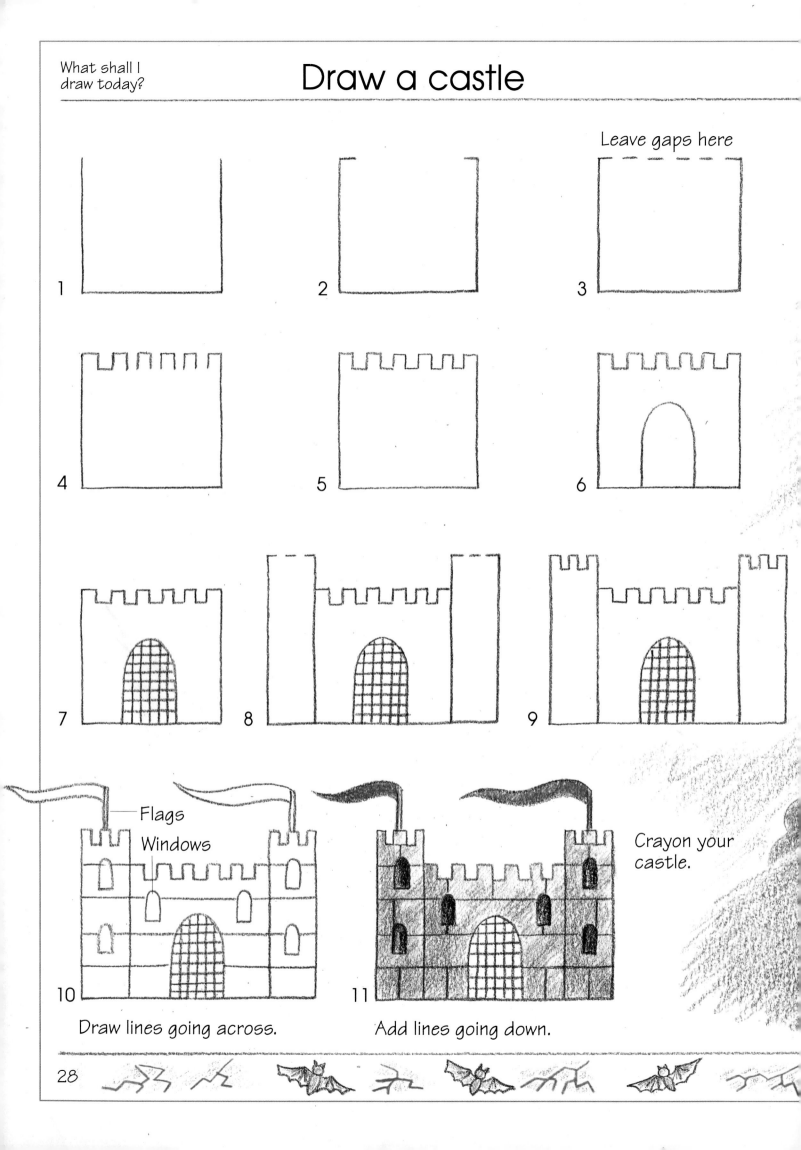

Leave gaps here

1

2

3

4

5

6

7

8

9

Flags

Windows

10

Draw lines going across.

11

Add lines going down.

Crayon your
castle.

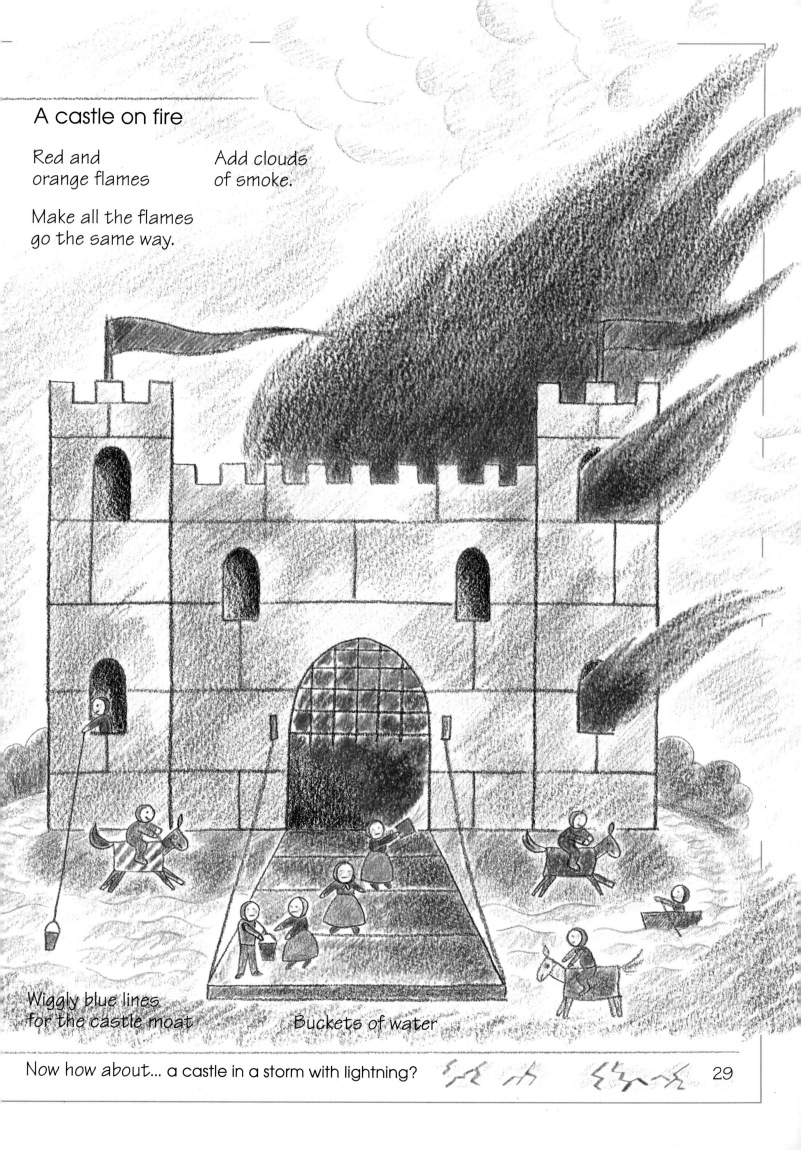

A castle on fire

Red and
orange flames

Add clouds
of smoke.

Make all the flames
go the same way.

Wiggly blue lines
for the castle moat

Buckets of water

Now how about... a castle in a storm with lightning?

Draw a pick-up truck

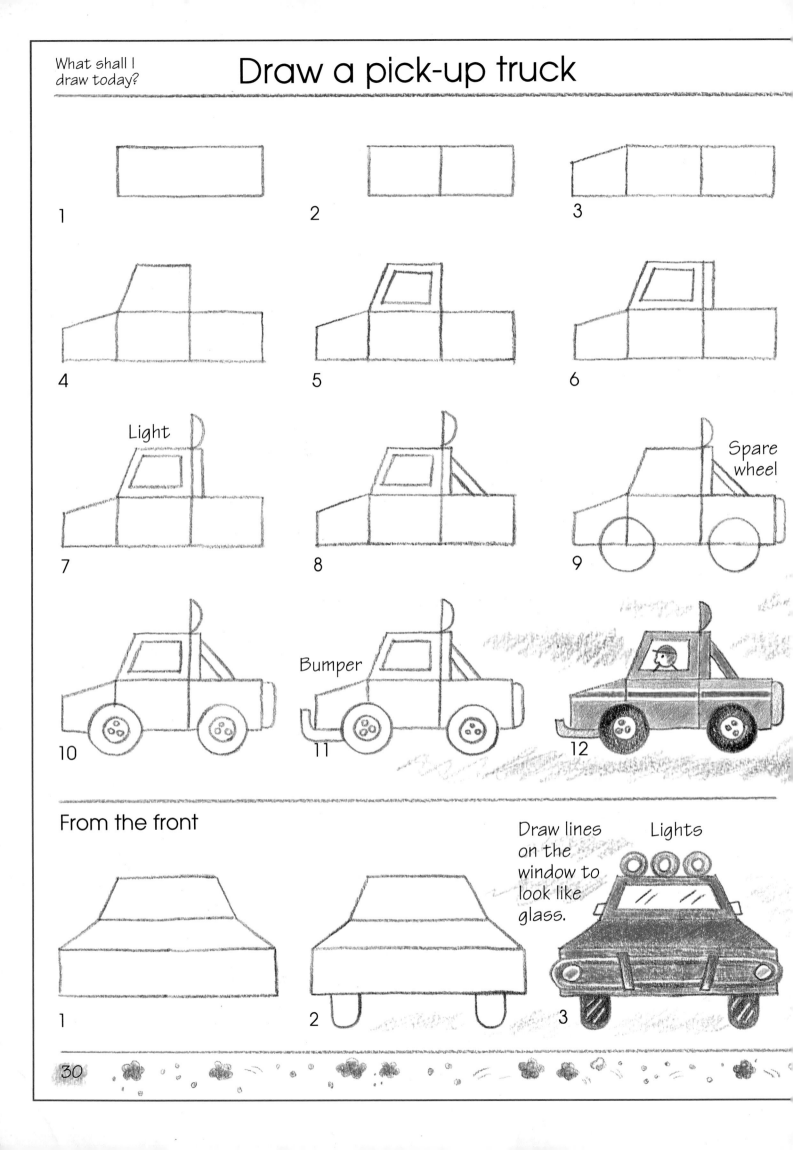

1

2

3

4

5

6

7 Light

8

9 Spare wheel

10

11 Bumper

12

From the front

Draw lines on the window to look like glass.

Lights

1

2

3

Draw a car

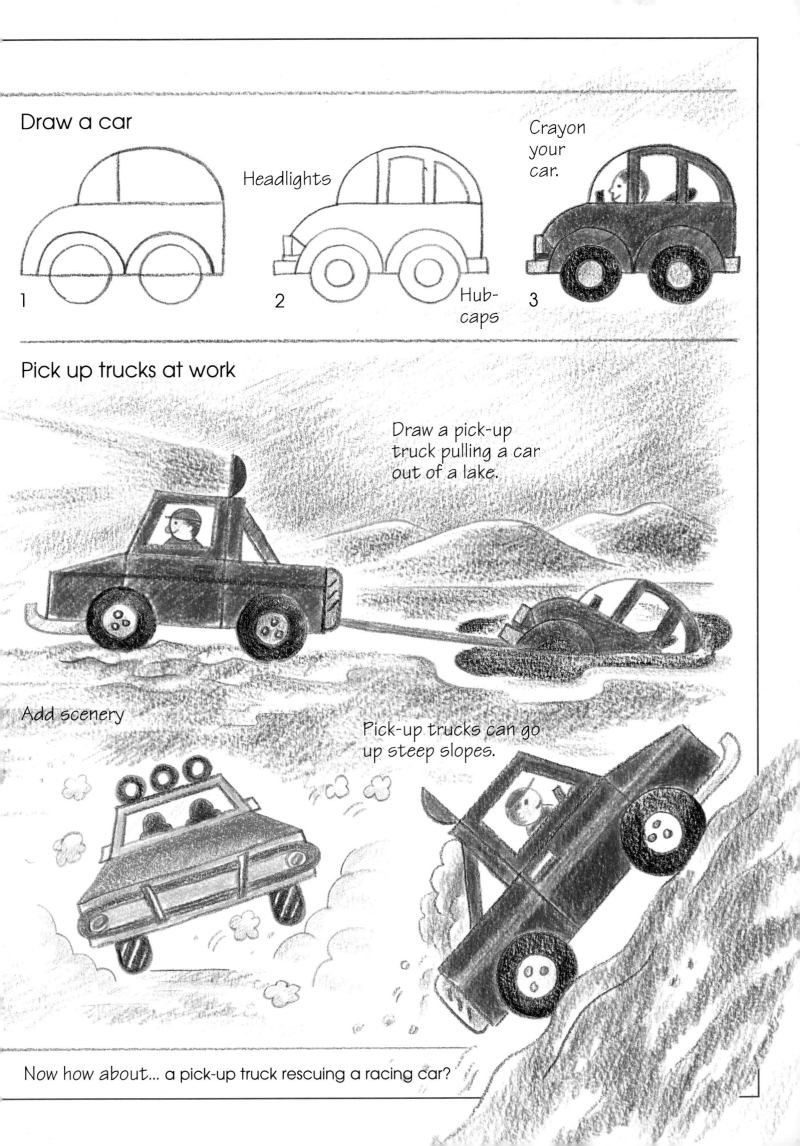

Headlights

Crayon your car.

1

2

Hub-caps

3

Pick up trucks at work

Draw a pick-up truck pulling a car out of a lake.

Add scenery

Pick-up trucks can go up steep slopes.

Now how about... a pick-up truck rescuing a racing car?

Things to do with your drawings

Mounting

1

Take a piece of paper or cardboard, a little bigger than your drawing.

2

Spread glue thinly over the back of the drawing. Put it in the middle of the mount.

3

With clean hands, smooth your drawing down firmly.

Fancy mounts

Decorate your mount with wrapping paper.

Cut a wiggly edge for your mount with scissors.

Draw a simple pattern on your mount.

Sprinkle glitter on your mount or stick on shiny stars.

Making a shaped card

Fold a piece of cardboard in half. Stick your drawing close to the fold. Leaving the folded side, cut around your drawing, close to the edge.

This edition first published in 2002 by Usborne Publishing Ltd., Usborne House, 83-85 Saffron Hill, London EC1N 8RT, England. www.usborne.com Copyright © 2002, 1994 Usborne Publishing Ltd.